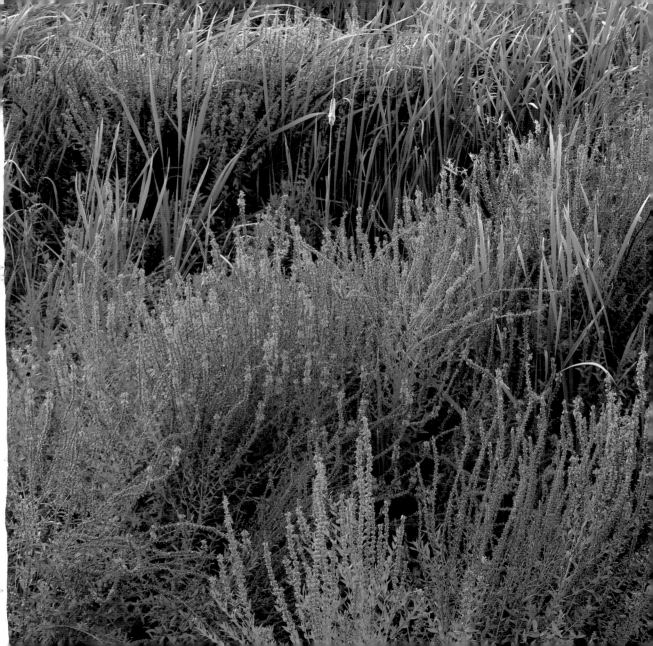

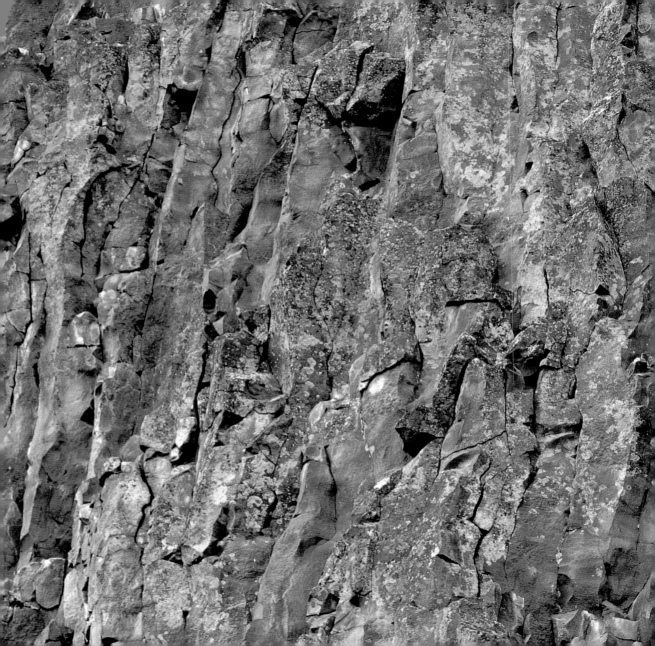

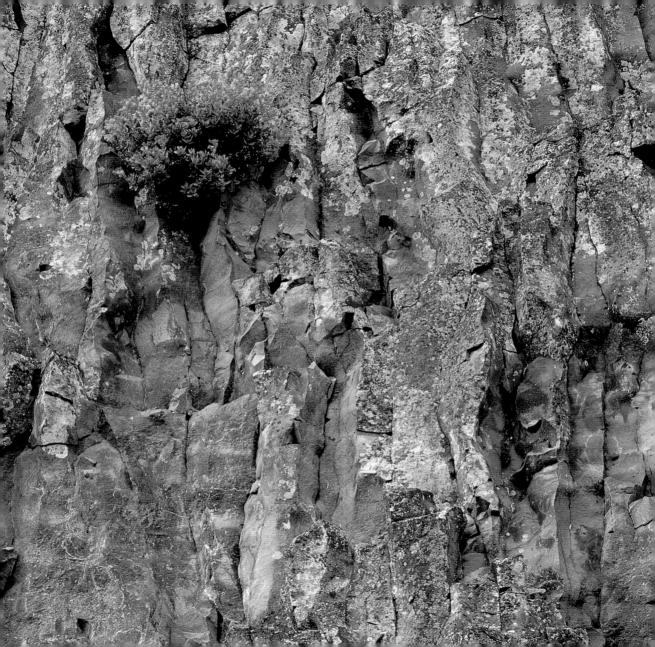

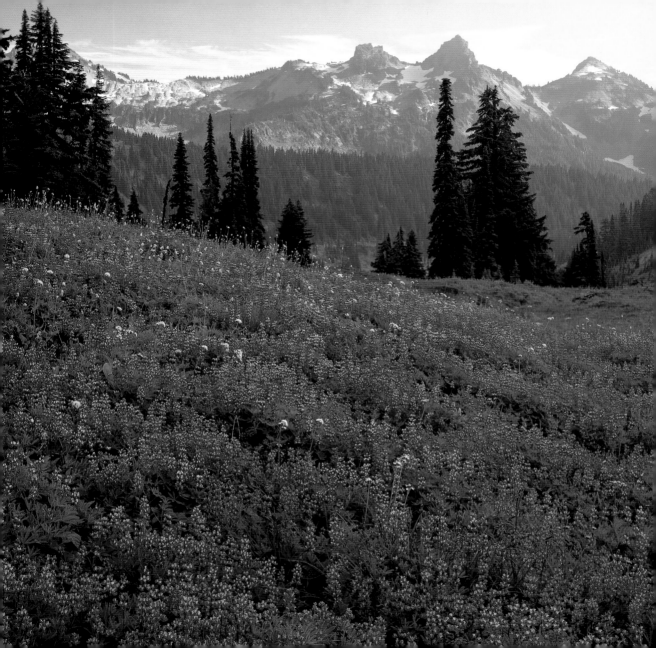

WASHINGTON WILDFLOWERS

Photography by Charles Gurche
With Selected Prose & Poetry

Washington Littlebooks

Westcliffe Publishers, Inc., Englewood, Colorado

To Sara, who always helps my vision to grow.

First frontispiece: Cattail and purple loosestrife, near the town of George
Second frontispiece: Cliff penstemon on lichen-covered bluff, Columbia Gorge
Third frontispiece: Lupine meadow below Tatoosh Range, Mount Rainier National Park
Opposite: Cinquefoil and bluebells, Olympic National Park

International Standard Book Number: 1-56579-137-1
Library of Congress Catalog Number: 95-62431
Copyright Charles Gurche, 1996. All rights reserved.
Published by Westcliffe Publishers, Inc.
2650 South Zuni Street, Englewood, Colorado 80110
Publisher, John Fielder; Editor, Suzanne Venino; Designer, Amy Duenkel
Printed in Hong Kong by Palace Press

Original prints available, contact Charles Gurche
at 509-534-2783

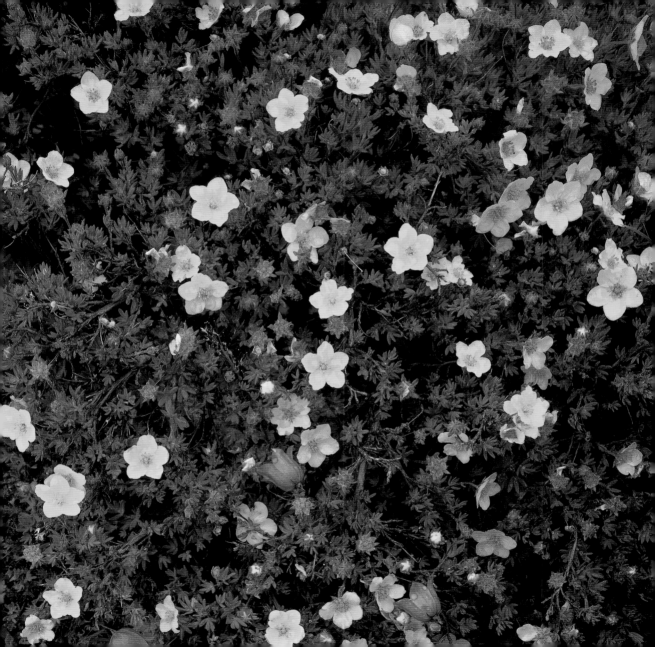

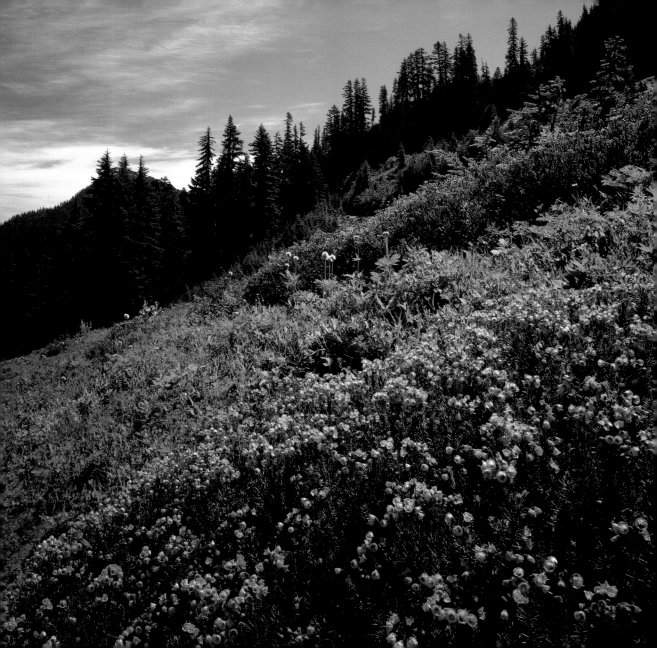

PREFACE

At an elevation of 3,000 feet, dense forest dominates the Washington landscape. On the forest floor, wildflowers peek out here and there, shade-loving and isolated beneath the towering canopy. A trillium, small and fragile, is surrounded by massive trunks of hemlocks and firs. Blossoms hide in the shadows of deep forest greens and browns.

At 4,000 feet, the forest begins to thin. Fragments of open sky allow more sunlight in, to support different varieties of flowering plants. Patches of lupine, sprinkled with aster and monkshood, appear in the forest glades. Shooting stars and columbines decorate small, damp meadows along mountain streams.

The forest thins even more in the higher elevations near 5,000 feet, and alpine flowers thrive. Lupine and Indian paintbrush blanket the bases of higher peaks. On open rock slopes, pink penstemon and purple phlox cling to exposed cliffs, their roots anchored in cracks and crevices. Water-loving pink and yellow monkeyflowers border cascading streams, thriving in the late days of summer. In the narrow band between the lower forests and barren rock above, wildflower gardens flourish.

At 6,000 feet, conditions are too harsh for many flower species. The hardy mountain heather, adapted to this environment, grows tiny flowers on low branches sturdy enough to survive the strong mountain winds. Among bare and broken rocks, a scattering of other small flowers, such as the endangered piper's bellflower and bright yellow cinquefoil, flourish in this desolate landscape.

Each elevation with its unique temperature, soil, rain, and snowfall conditions, supports a variety of plants. Flowers have adapted to every niche possible. Some species may be singularly small, but each is important in the web of life.

The extensive field of flowers known as Paradise Meadows in Mount Rainier National Park are perfect for observing this diversity. Buried with up to twenty feet of snow for eight or nine months each year, the gardens bloom

Pink mountain heather, Mount Rainier National Park

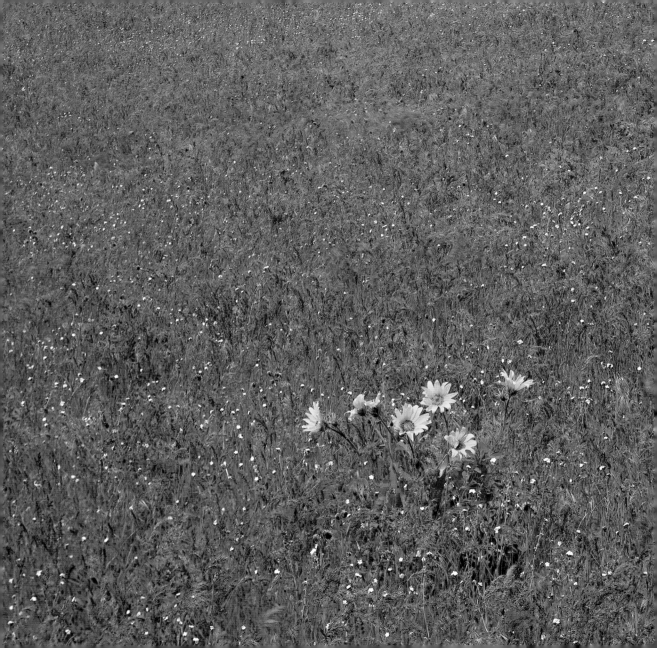

quickly after the summer snowmelt. At the edge of timberline and facing south, the area presents one of the most magnificent flora displays each July and August. The trail to Sluiskin Falls offers peaceful seclusion from the crowds.

As summer colors peak in Washington's Olympic and Cascade ranges, the arid lowlands of the Columbia River lie parched and brown. The desert blooms early, in the springtime sun, while the high country remains under a blanket of snow. Amazingly, a few of the same flowers thrive in both alpine and desert settings. Lupine neighbors sagebrush, for example, and penstemon clings to lofty basalt walls. Other flowers are found only in drier climates, like the showy arrowleaf balsamroot, which flourishes in the summer heat and mild winters of the Columbia Basin.

In eastern Washington, one spring that I remember well produced an incredible display of flowering alkanet and snapdragon. The flowers grew so thick in places that meadows glowed with beautiful profusions of purple and yellow. The bold contrast of the flowers' colors, opposites on the color wheel, created striking abstract designs. What was it that triggered such a display that year? In the previous winter, snow covered the ground for 110 days, resulting in weeks of constant moisture during snowmelt in the early spring. The cycles of nature create endless surprises when it comes to spring and summer's bloom.

When photographing wildflowers, I try to find a connection between the flowering plant and its environment — a field of flowers receding into a misty fog, a single flower against a pattern of grasses, blossoms crowding the trunk of an old oak, flowers beside rushing waters, beneath high mountain peaks, or clinging to lichen-covered boulders.

To take a good photograph, there is always some visual puzzle to solve. My love for photography is rooted in this passion of continually searching for new solutions. Using the techniques of composition and light I try to create a more interesting design or a stronger mood, to make a photograph that captures the inspiration I find in the natural world.

—Charles Gurche
Spokane, Washington

Balsamroot and grasses, Columbia Gorge

"Beauty is truth, truth beauty—

that is all

Ye know on earth,

and all ye need to know."

— John Keats, *Ode to a Grecian Urn*

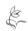

Meadows beneath Mount Baker,
Mount Baker-Snoqualmie National Forest

"Flowers have expression of countenance
as much as men or animals. Some seem to smile;
some have a sad expression; some are pensive and diffident;
others again are plain, honest and upright…"

— Henry Ward Beecher, *Star Papers: A Discourse of Flowers*

Bull thistle, Turnbull National Wildlife Refuge

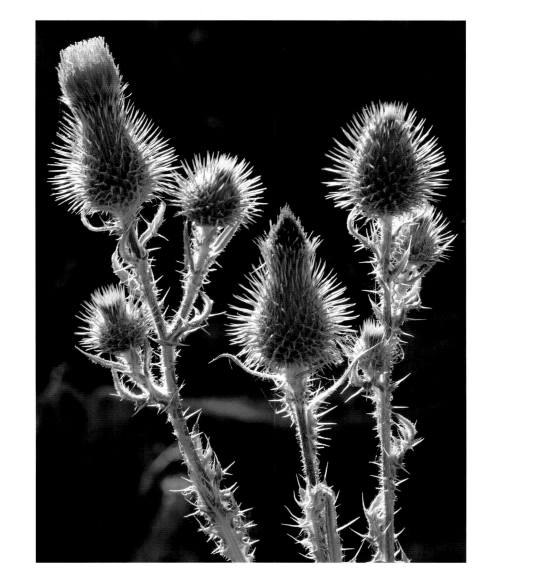

"The earth laughs in flowers."

— Ralph Waldo Emerson, *Hamatreya*

Balsamroot, lupine, and paintbrush, Columbia Gorge

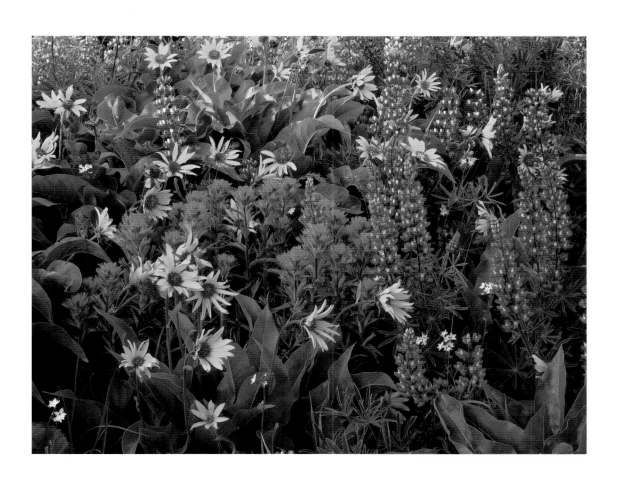

"Flowers...are like lipstick on a woman...it just
makes you look better to have a little color."

— Lady Bird Johnson,
Time magazine, September 5, 1989

Phlox growing in a crevice, Mount Rainier National Park

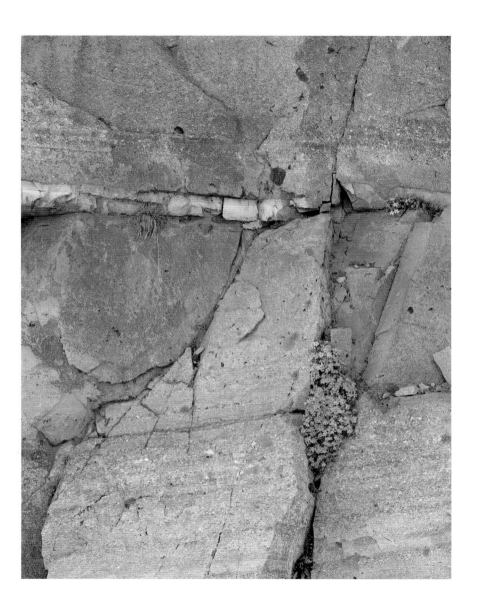

"Nothing in the world is single,

All things by law divine

In one spirit meet and mingle."

— Percy Bysshe Shelley, *Love's Philosophy*

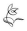

Indian paintbrush, Spray Park, Mount Rainier National Park

Overleaf: Common alkanet among grasses, Nine Mile Falls

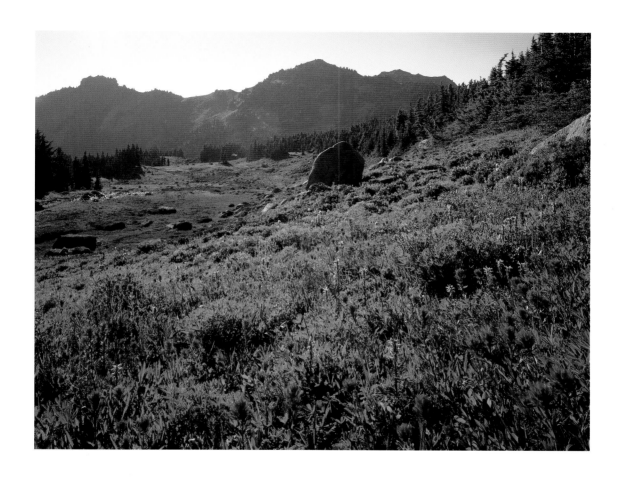

"The flower is the poetry of reproduction. It is an example of the eternal seductiveness of life."

— Jean Giraudoux, *The Enchanted*

Pink mountain heather, Mount Rainier National Park

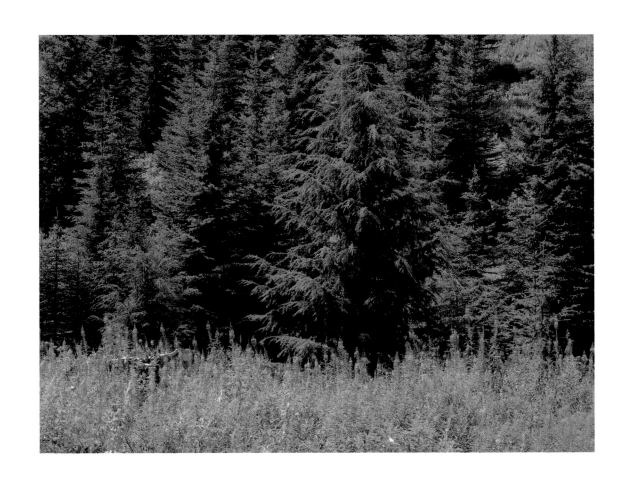

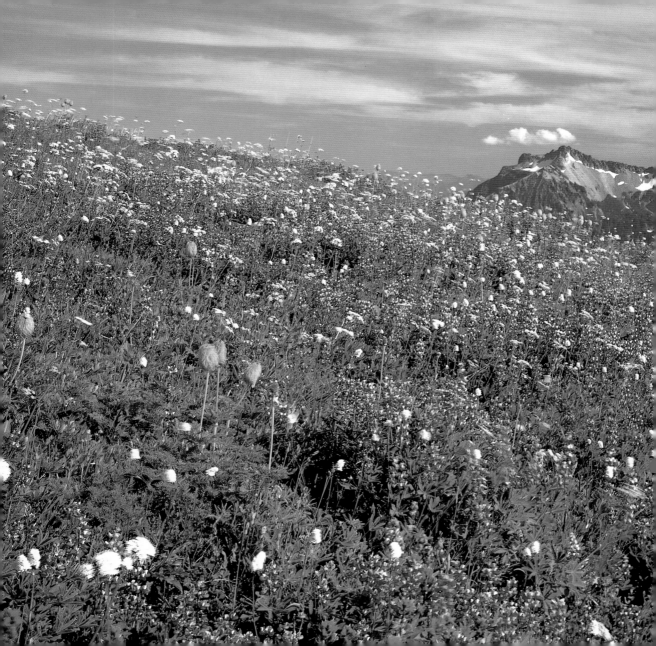

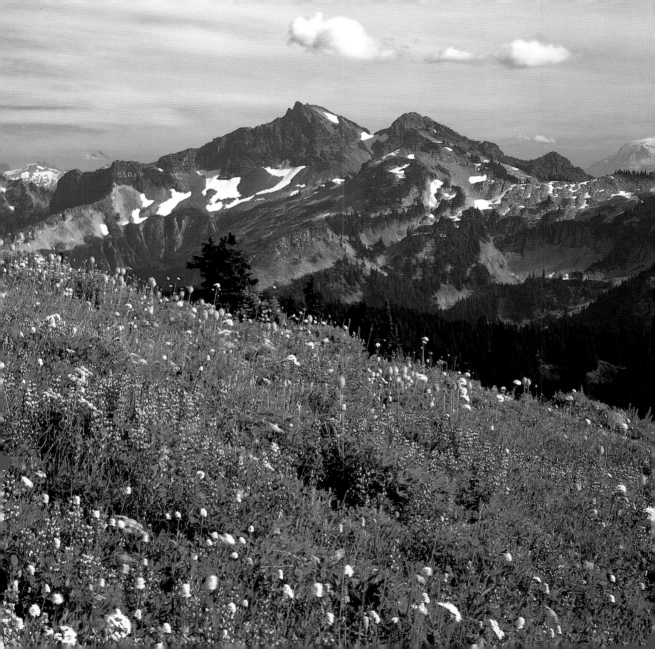

"Beauty is its own excuse for being."

— Ralph Waldo Emerson, *The Rhodora*

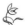

Golden yarrow, Columbia River Gorge National Scenic Area

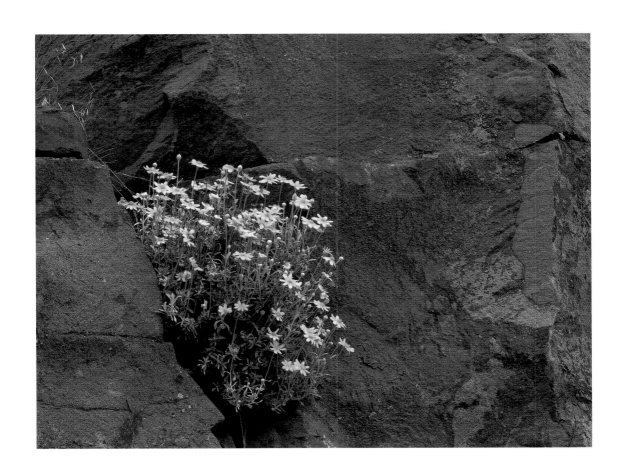

"You must not know too much, or be too precise or
scientific about birds and trees and flowers…
a certain free margin…helps your enjoyment
of these things."

— Walt Whitman, *Specimen Days*

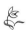

Tansy and grasses, Spokane County

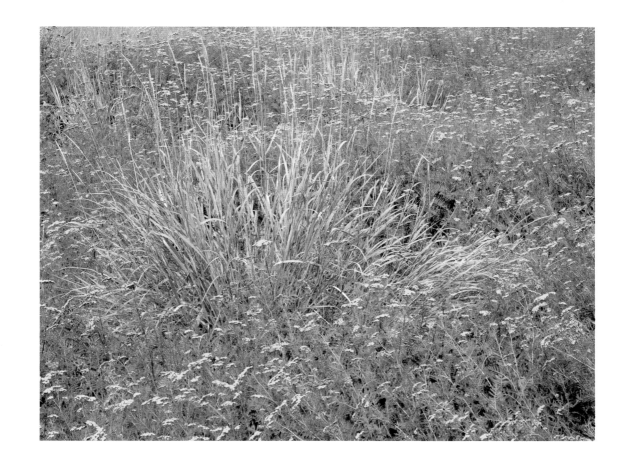

"To create a little flower is the labour of ages."

— William Blake, *Proverbs of Hell*

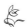

Lupine meadow beneath Mount Rainier,
Mount Rainier National Park

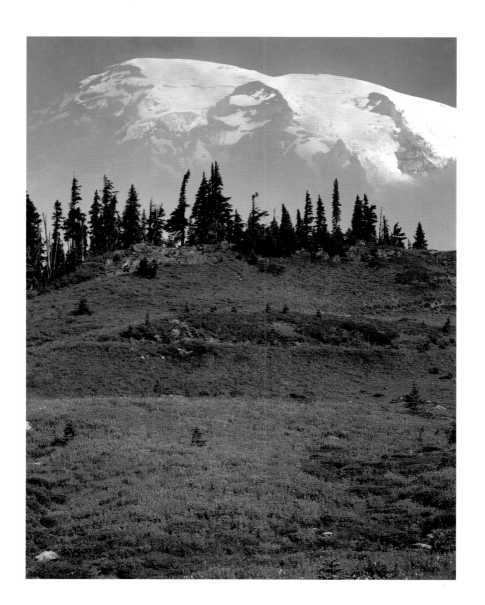

"Work — for some good, be it ever so slowly;

Cherish some flower, be it ever so lowly..."

— Frances Sargent Osgood, *Laborare est Orare*

Hawthorn leaves and aubrieta, Spokane County

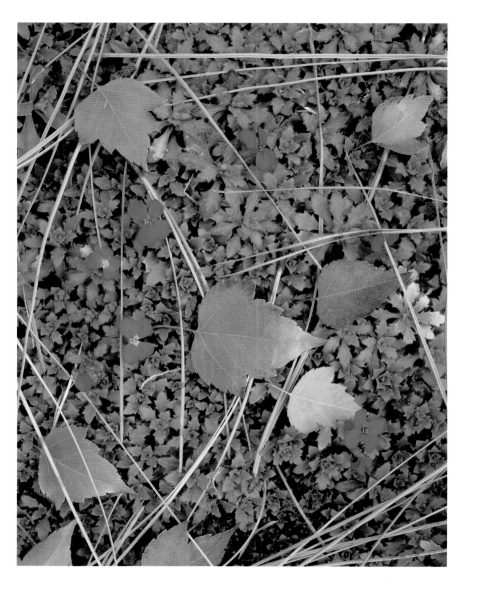

"Beauty is a primeval phenomenon…the reflection of
which is visible in a thousand different utterances of
the creative mind, and is as various as nature herself."

— Goethe, from Eckermann's *Conversations*

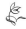

Lupine, Steptoe Butte State Park, Palouse Country

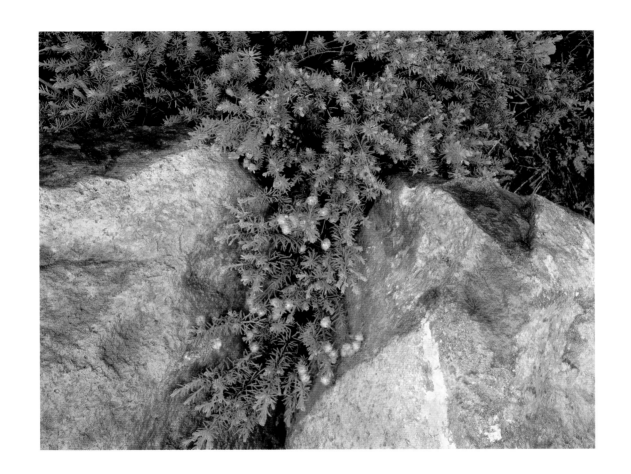

"Nothing is so like a soul as a bee. It goes from
flower to flower as a soul from star to star,
and it gathers honey as a soul gathers light."

— Victor Hugo, *Ninety-Three*

Golden yarrow, Columbia River Gorge National Scenic Area

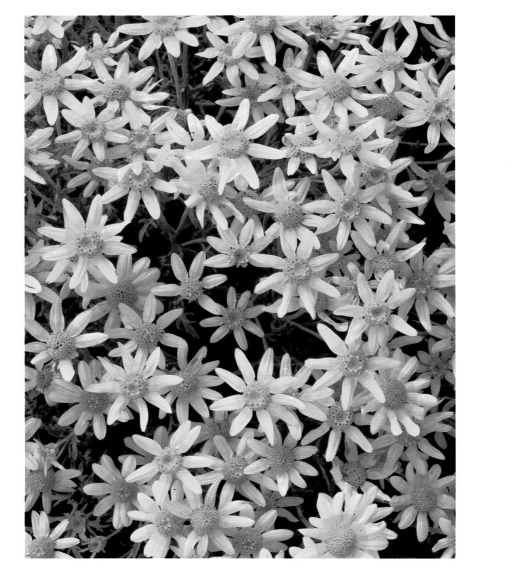

"To see a World in a Grain of Sand
And a Heaven in a wild Flower,
Hold Infinity in the palm of your hand
And Eternity in an hour."

— William Blake, *Auguries of Innocence*

Lupine meadows near Eagle Point, Olympic National Park

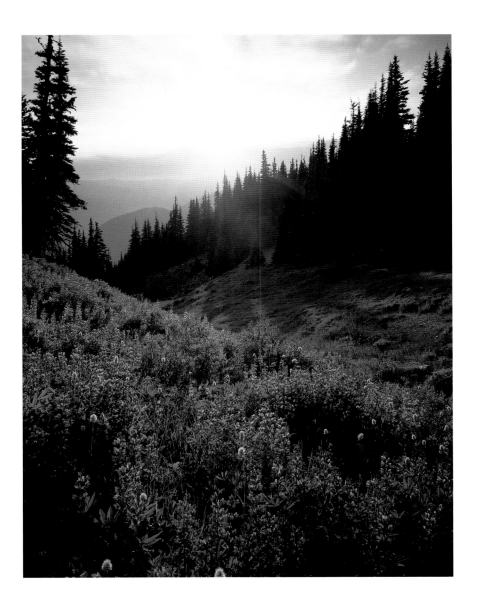

"The loveliest flowers the closest cling to earth…

The happiest of Spring's happy, fragrant birth."

— John Keble, *Spring Showers*

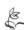

Sweet fennel, near the town of Lyle, Klickitat County

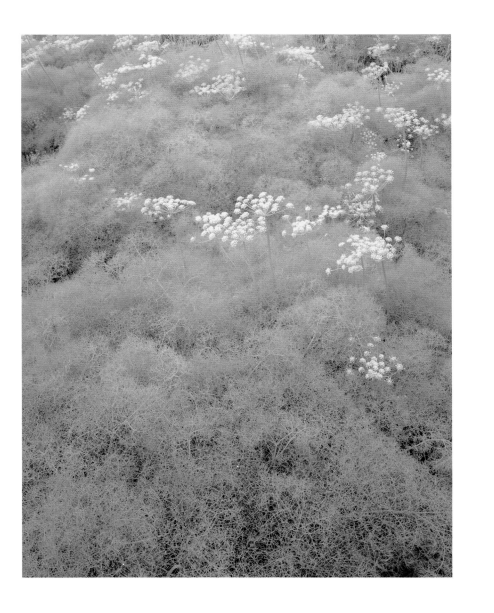

"I should like to enjoy this summer

flower by flower."

— Andre Gide, *Journals*

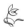

Indian paintbrush, lupine, and balsamroot, Columbia Gorge

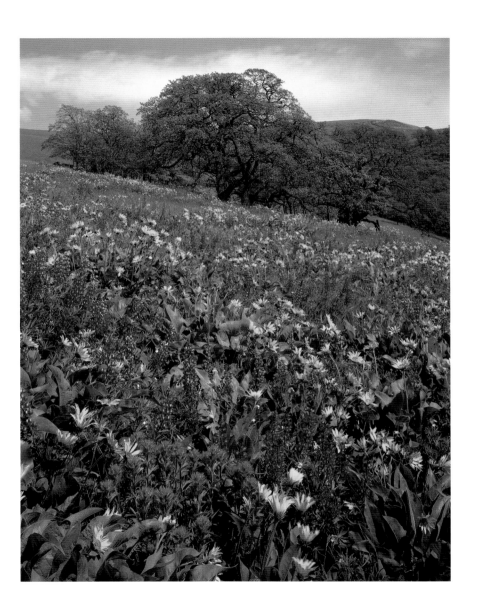

"Shed not tear — O shed not tear!

The flower will bloom another year.

Weep no more — O weep no more!

Young buds sleep in the root's white core."

— John Keats, *Faery Songs*

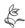

Nootka rose petals amid ponderosa pine cones, Riverside State Park

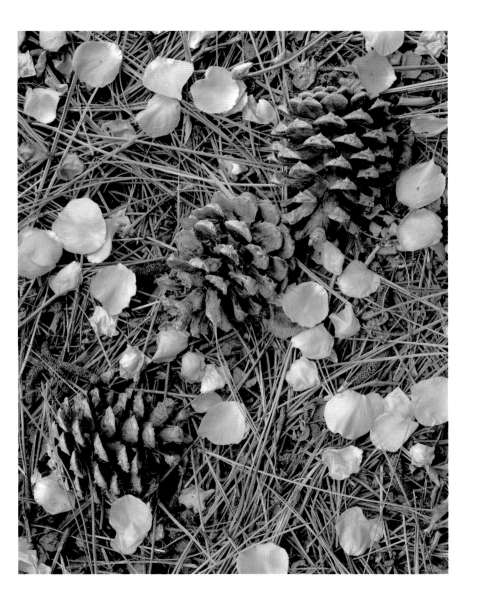

"How does the meadow-flower its bloom unfold?

Because the lovely little flower is free

Down to its root, and, in that freedom bold."

— William Wordsworth,
A Poet! He Hath Put His Heart to School

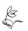

Fireweed and Douglas fir,
North Cascades National Park

Overleaf: Lupine and paintbrush beneath the Tatoosh Range,
Mount Rainier National Park

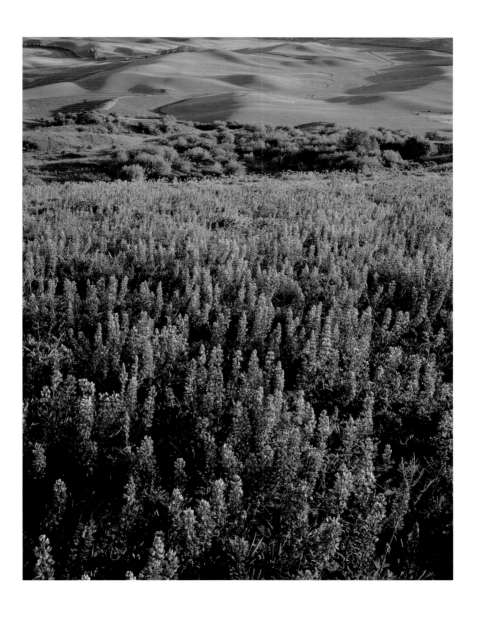

"A charm that has bound me with the witching power,

For mine is the old belief,

That midst your sweets and midst your bloom,

There's a soul in every leaf!"

— Maturin Murray Ballou, *Flowers*

Yellow balsamroot and purple lupine, Columbia Gorge

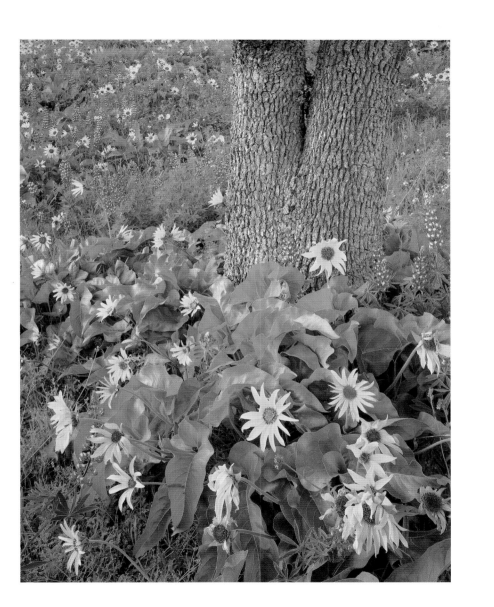

"Flowers are words

Which even a baby may understand."

— Arthur C. Coxe, *The Singing of Birds*

Alpine pinks, Spokane County

Overleaf: Pink mountain heather, North Cascades National Park

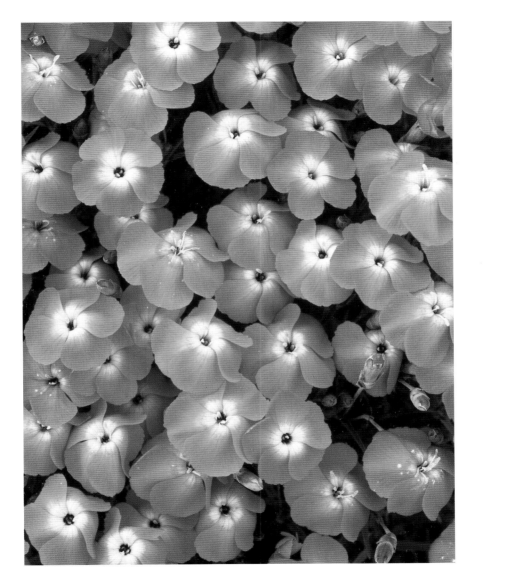

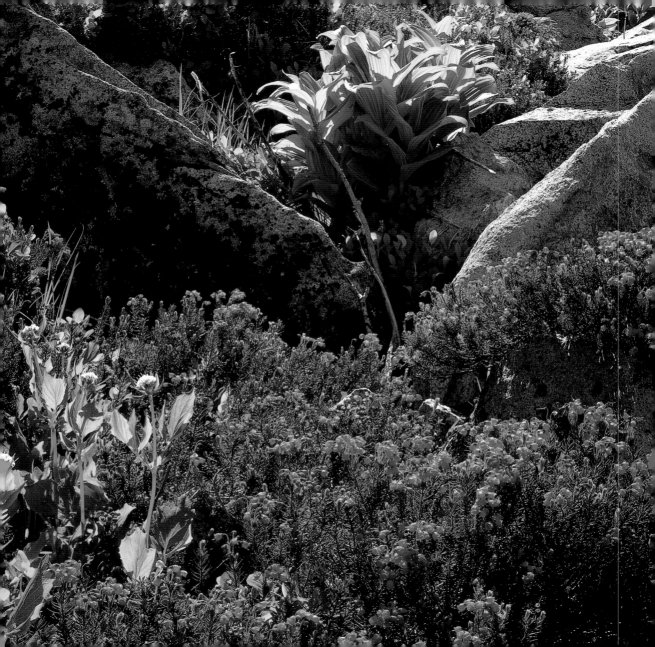

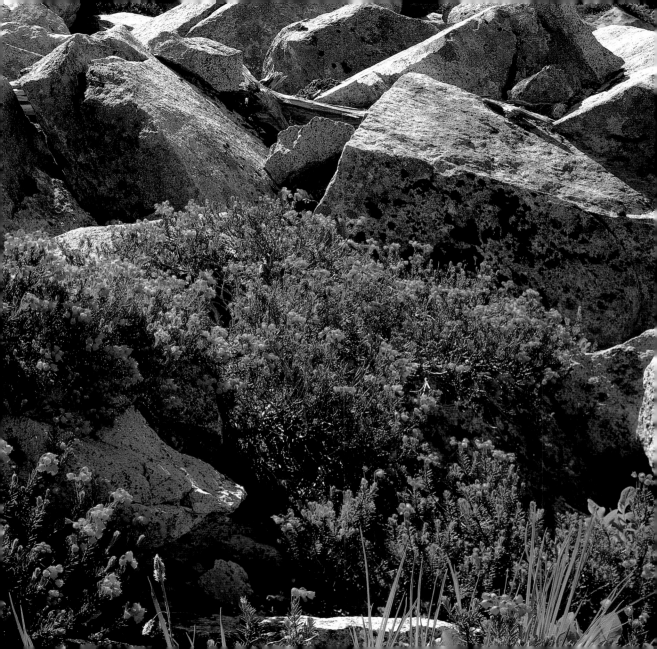

"And 'tis my faith, that every flower

enjoys the air it breathes."

— William Wordsworth, *Lines Written in Early Spring*

Goatsbeard and vetch, Spokane County

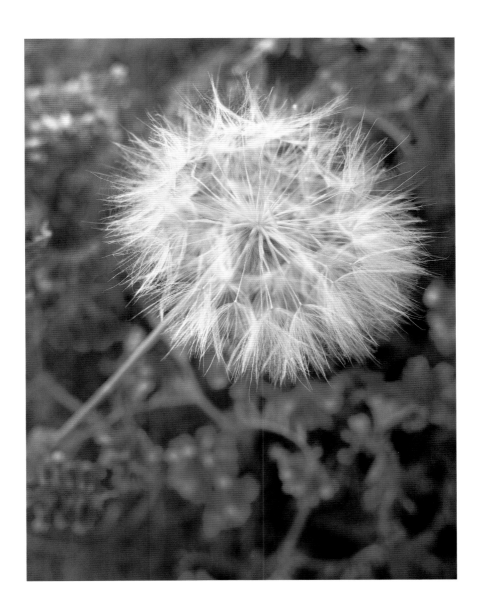

"Spring lightens the green stalk, from thence the leaves
More aerie, last the bright consummate flower."

— John Milton, *Paradise Lost*

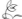

Yellow iris, near Dartford, Spokane County

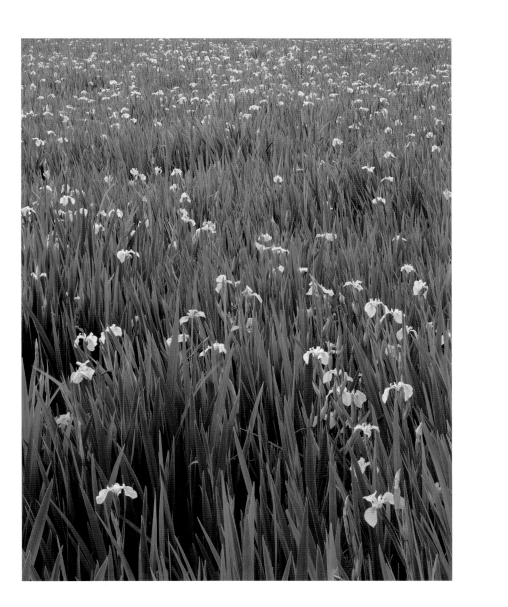

"Throw hither all your quaint enamell'd eyes
That on the green turf suck the honied showers,
And purple all the ground with vernal flowers."

— John Milton, *Lycidas*

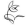

Lupine meadow on Hurricane Ridge, Olympic National Park

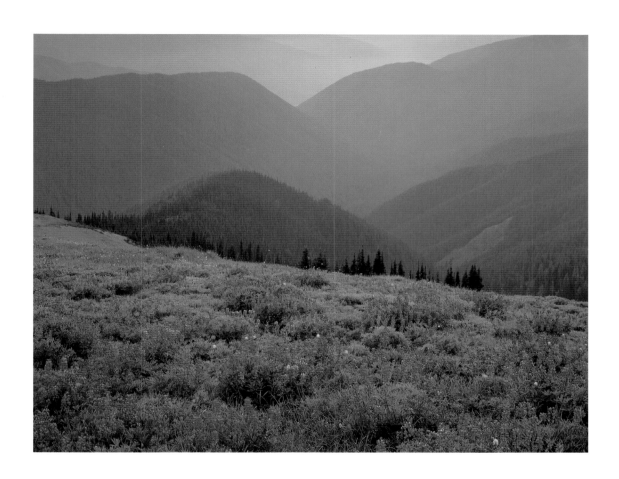

"The Amen! of Nature is always a flower."

— Oliver Wendell Holmes,
The Autocrat of the Breakfast-Table

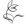

Monkeyflowers along the Paradise River,
Mount Rainier National Park

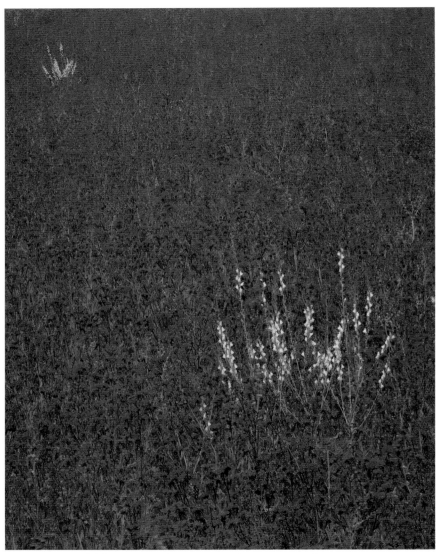

Yellow snapdragon amid common alkanet,
near Nine Mile Falls, Spokane County